Born in 1924 in rural Kerala, K. G. Subramanyan played a pivotal role in shaping India's artistic identity after Independence. Initially studying economics, his involvement in the freedom struggle led to his imprisonment and debarment from college. He then joined Kala Bhavana, Visva-Bharati University, Santiniketan, which proved to be an enduring association. Graduating in 1948, he worked under such luminaries as Benode Behari Mukherjee, Nandalal Bose and Ramkinkar Baij. Subramanyan then taught at M. S. University, Baroda, and returned to his alma mater in Santiniketan as a professor in 1980.

Mani-da, as he was fondly called, seamlessly blended the elements of modernism with folk expression in his works that spanned paintings, murals, sculptures, prints, set designs and toys. His visual meditations contemplated human subjects and objects as distinct forms, characterized by vibrant colours and abstract shapes. Renowned for the sensuality in his imagery, reflective faces and nightly backdrops, his paintings reflected a cubist influence. Subramanyan skilfully blended romanticism with wit and eroticism, drawing inspiration from myth, memory and tradition. Beyond his visual artistry, his writings have laid a solid foundation for understanding the demands of art on the individual.

Spanning nearly seven decades, Subramanyan's art was featured in over fifty solo exhibitions, receiving prestigious awards such as the Medallion of Honourable Mention (Sao Paulo Biennale, Brazil) and the Lalit Kala Akademi's National Award. In 2012, he received the Padma Vibhushan, India's second-highest civilian award, for his outstanding contribution to the arts. He remained dedicated to teaching until his retirement in 1989, following which he was appointed as a professor emeritus at Visva-Bharati.

In the later stages of his life, Subramanyan lived with his daughter in Baroda, where he passed away in 2016 at the age of 92. His contributions have left an indelible mark on contemporary art, blending tradition with innovation.

BIRTH CENTENARY EDITION

ALSO AVAILABLE

Cat's Night and Day

Death in Eden

How Hanu Became Hanuman

How Poppy Grew Happy

In the Zoo

The King and the Little Man

Our Friends, the Ogres

Robby

The Tale of the Talking Face

*When God First Made Animals,
He Made Them All Alike*

A Summer Story

Enchantment and Engagement
The Murals of K. G. Subramanyan
By R. Siva Kumar

Letters

The Living Tradition
Perspectives on Modern Indian Art

The Magic of Making
Essays on Art and Culture

Moving Focus
Essays on Indian Art

Poems

Seventy-Three

Sketches Scribbles Drawings

K. G. SUBRAMANYAN

Letters

LONDON NEW YORK CALCUTTA

Seagull Books, 2024

First published by Seagull Books, 2008

© Seagull Books, 2024

ISBN 978 1 80309 452 6

British Library Cataloguing-in-Publication Data

A catalogue record for this book is available from the British Library

Typeset and designed by Seagull Books, Calcutta, India

Printed and bound by Hyam Enterprises, Calcutta, India

PREFACE TO THE FIRST EDITION

These days you are asked to express your views about people, institutions and things all the time. This is standing practice in a democratic society—even if it is a notional one—for it attaches some value to every man's opinion.

Of late, with the amazing improvements in the techniques of interpersonal communication, this practice has widened enormously. You are harassed by requests to SMS your views about people, commodities and events, to evaluate their character and quality. This is surely part of the promotional strategies devised by a many-sided consumer society.

I am too old to be part of this latter scene; I still do not know how to send or receive an SMS. But over the last 40 years, I have sometimes responded to requests from various quarters about my willingness or lack thereof to do something or give advice on some issue or other. I have no definite proof that my responses have had an impact, for, through the years, the scene has not undergone any decided change.

I knew of this possibility. Why did I then respond to these questions at all? Perhaps because it gave me a chance to think about certain issues to which I would otherwise have not paid attention. And in the process, to clear my horizons.

These letters should be taken in that light—as small footnotes to a process of self-discovery, even though a lot of time has passed and the circumstances undergone drastic change.

ONE

Kailas
13 Purvapalli
Santiniketan 731235

Shri Arjun Singh
Minister of Human Resource Development
Government of India
New Delhi

9 October 1991

Dear Arjun-ji,

I have your kind letter NO. 1017-I M(HRD)91 with no date.

I give below my views for whatever they are worth.

To me, the most attractive aspect of Rajiv Gandhi is his personifying the aspirations of the Indian youth for a peaceful, free, progressive and prosperous India, touched perhaps with some impatience and naivete but backed, nevertheless, by a resolve to work towards it.

Those of his followers who tried to boost his image to the dimension of Mahatma Gandhi or his grandfather, Jawaharlal Nehru, did him injustice; his distinction is not in being a superstar or even a superyouth but in being one amongst the many and, thereby, giving the many the feeling that what he can do or dream to do, they can as well. I suspect that in his heart of hearts he wanted to be no matinee idol but a man of action.

So any memorial to him, I feel, should have as its focus *action,* not *worship.*

His touching statement *I too have a dream* can here serve as a pointer. His dream is also the dream of many—a united India where people forget their differences and work together to make it one of the foremost nations of the world, free of inequalities and injustice, as proud of its past as it is sure of its future.

The realization of this dream needs the spread of education and the scientific temperament among the youth, and inspiring them with the confidence that they have the means to achieve this dream. Such confidence alone can counteract the panic that has gripped their hearts and that will not let them proceed beyond the service of self. And it needs them to be convinced that their interests are inalienably bound with those of their country.

Educating the youth about the country's potential and the new knowledge that can draw it out of stagnation, keeping fully in mind the larger human concerns thus becomes our prime necessity and goal.

In light of this, I should think the samadhi itself should be one of utmost simplicity—for instance: a plain white marble slab inscribed with *I too have a dream* in many languages, in attractive calligraphy, surrounded perhaps with a shallow moat of clear water (or something simulating it) that reflects the heavens, its surface seemingly afloat with some marble sculptures resembling white lotuses and water plants.

But the main memorials should be *two activity centres* that will attract the youth all year round, not just on the anniversary days, and that will educate them about the right action.

One should educate them about India's potential and *the other*, infuse them with the scientific attitude, introduce them to the achievements of science and demonstrate their usefulness to realize this potential and enlarge its horizons.

This could be done through exhibitions, video shows, films, lectures, discussions, melas, every kind of artifice possible to inveigle their participation; these activities should be planned as a continuous year-long chain of events.

The activities should be designed and monitored by the best minds of the land. And, to extend their impact, they should be carried out by what may be called Rajiv Study Circles or Rajiv Social Education Programmes that will disseminate the information and the message to, and incite active thinking among, different levels of society, through personal contact, communication media, educational kits, etc. etc.

My personal suggestion for Sriperumbudur is the building of a Hall of Progress that involves all these features and that will serve as a South Indian nerve centre for the aforesaid objectives; that will bury the memory of the unpleasant incident under a spate of activity with the country's development and unity in view.

It may be that my suggestions will not find acceptance with many as they offer no place for ritualistic homage. But we have to, at some time or other, grow out of the stranglehold of personal nostalgia and

get down to nation-building. And, if necessary, lay down new norms of behaviour—cut out this endless laying of wreaths and spouting of pious homilies and pay more attention to the legacy of ideas each one leaves behind.

With warm regards,
Yours sincerely,
K. G. Subramanyan

TWO

Kailas
13 Purvapalli
Santiniketan 731235

Shri Wajahat Habibullah
Officer on Special Duty
Ministry of Urban Development
Government of India
New Delhi

27 August 1994

Ref: D. NO. 317-OSDE/D/94 dated 8 August 1994.

Dear Shri Habibullah,

Your kind letter. The Honourable Minister and you are doing me an honour. But I would like to be left out of this.

First, for ideological reasons. I have serious reservations against such apotheosis of the dead. And this kind of forced image-building.

If anyone on our national scene really deserves to be apotheosized, it is Mahatma Gandhi (though he would not have countenanced it). He was the only one who had a timeless vision. But in today's India, he is nobody. People are ashamed to say that they are his followers.

Today, it is Rajiv Gandhi everywhere. Our nation's topmost leaders tom-tom their allegiance to him. Everything is attributed to

him or named after him. They make it sound as if the history of India started with Rajiv Gandhi. Old-fashioned as I am, I find the vulgarity of such thoughtless adulation distasteful. And not being one of those midnight's children, I remember the past with painful nostalgia. Even the Rajiv I remember is a handsome, pleasant young man with a dream, be it an inchoate dream, for the prosperity of India; not this mannequin on whom every astute politician or planner drapes his overcoat. Maybe this is in the spirit of the times. I confess I am out of tune with it.

Besides, at my age, I want to devote the little time I have left to do what I have vocation for, and not spend it on projects that are not close to my heart. And my own health and circumstances no longer permit me to travel around the country and attend meetings and proffer advice; I have done that for long years without any noticeable effect.

So kindly excuse me. I am sure Arjun Singh-ji will understand. There will be many young professionals who will readily associate themselves with such a project; but I am sorely out of touch to suggest any specific names.

Perhaps a sculptor like Shri Nagji Patel (art consultant to Indian Petrochemicals Corporation Limited, Baroda) may be useful to associate.

I am
Yours sincerely,
K. G. Subramanyan

THREE

Kailas
13 Purvapalli
Santiniketan 731235

Shri Ashok Vajpai
Joint Secretary
Department of Culture
Ministry of Human Resource Development
Government of India
New Delhi

20 August 1992

Dear Ashok-ji,

Thank you for sending me the approach paper for a National Policy on Culture and asking for my comments. I am very grateful that you have not asked me to come for a meeting in Delhi, which I would not have been able to attend in view of my wife's poor health and eyesight. I was unable to come to discuss the working paper on the National Policy of Education for the same reason. It is also why I have communicated my unwillingness to serve on the selection committee for the UNESCO awards for young talent.

I went through the paper, as I did too the paper on the National Policy on Education. Our paperwork is generally exemplary. And, with the various tracts and charters UNESCO reels out from time to time, this becomes easier still. So I have very little to say with regard to its content; it is fairly comprehensive even if in a disorganized way, which is inevitable in a matter with so many sides to it. If all this is implemented in a reasonable time frame, the government will have indeed achieved something.

But the main problem is in the area of implementation. So, to have a realistic picture, we should start the discussion with a kind of balance sheet clearly outlining: (1) what we planned to do to start with; (2) what has been done so far; (3) what remains to be done. And, in the process, separate those actions which are cosmetic from those of enduring value. At a second step, we should spell out what (material and human) resources we can muster and how. Then, to follow, draw up strategies of which a significant part will be concerned with defusing, bypassing or disarming the vested interests that have grown into the institutions and agencies as already exist.

As far as I can tell, a lot of our planning in the fields of education and culture does not get off the ground because of our inability to match our resources to our intentions, or vice versa. Talking about education: the grandiose work-education programme in schools is a poor caricature of what was intended, just because the schools have not had the kind of resources needed for such diversification. So even its basic purpose of motivating students to value manual work is not served. The gift packets of Navodaya Schools to undeveloped rural areas will have the same fate unless they have resources

enough to implement their programme effectively and extend it to the immediate public. Similarly, our universities start courses which they do not have resources to implement. Even their sanctioned funds are scaled down every year for some reason or other. So the faculty is led to worry more about the problem of its existence than the work it is entrusted with; it grows vested interests in the status quo and resists all innovation. In the field of culture too, the existing institutions resist all change; the work of the Akademis have been surveyed by at least two commissions in the last three decades and been found wanting, but the government has not been able to effect any improvement. This is just to explain the necessity of (1) matching our intentions to the resources we can raise while making a plan, and of (2) being aware of the power of vested interests to stonewall change while drawing up the strategies.

A large part of any government's cultural policy will be taken up directly with (1) conservation of cultural property (sites, museum holdings, collections); (2) their full documentation and study to build as complete an archive of information as is possible for scholars and specialists; (3) their publication; and (4) the encouragement of traditional practices wherever they exist and the creation of circumstances for their survival and expansion. Indirectly, it will be taken up with (5) the encouragement of creative expression in the present-day world and, towards this, providing the facilities and funds needed for its growth and the growth of public interest and appreciation.

True, the government will need to enlist the support and cooperation of various private and public agencies in this; and have a clear picture of what they are doing to avoid wasteful duplication of work.

It should also have a clear picture of what it (with its component institutions) has achieved so far. I doubt whether there is a starting brief before any new action is planned. For instance, this paper (on p. 19) mentions that our classical traditions have already been fairly well described and documented. Is this true? And to what extent? There are no authentic records of large areas of our traditions. Just think of the murals and wood sculptures of Kerala temples—there is no sizeable archive of information and visual documents of these even in Kerala. One can mention so many others. And even the information that is available is hardly ever brought to public notice. I doubt whether the invaluable holdings of our museums have still been fully documented and described, let alone published.

So while the necessity of documenting the so-called folk arts, non-professional arts and ephemeral arts is urgent, we should not be complacent about what has to be done in other areas. Realistically speaking, it will be more profitable to think of the art or cultural scene in a total perspective than breaking it into sectors with various priorities (i.e. 'mandalizing' it). In fact, the dangers inherent in such division is hinted at in your paper itself.

What I would suggest is that the Department of Culture put together a complete cultural map of India, if it does not have one already. And make a periodical report on which areas have received attention (by way of conservation, documentation, publication, etc.) and which have not. This will facilitate methodical coverage of the whole area within a settled time frame. And the documents and information gathered should be housed in a central archive or chain of archives. I presume the Indira Centre was conceived to be a centre

of this kind; has it made any progress in this line? Collection of cultural facts should precede theoretical speculation and public displays, though I do not understate their value. If we go on waiting, the facts we seek to document or conserve will disappear or will be taken advantage of by more enterprising scholars from other parts of the world. Already in the area of arts, philosophy, even classical languages, there are more specialists in Western centres of learning than in our own. It makes one hang one's head in shame when a foreign graduate makes critical comments on Sayana's commentary on the Vedas, while at home, even in the erstwhile reputed centres, Vedic scholarship is waning.

Such a time-bound programme should result in the accumulation of material that can incite further research and study. This is absolutely essential if our living scene has to flourish. Such a groundwork, covering the total cultural scene, will naturally need sizeable resources and the freedom to use them without the usual bureaucratic red tape. If an institution like Bharatiya Sanskriti Parishad will help in this, I am all for it. But where will the resources come from? The government, with its various constraints, will never be able to earmark enough funds for culture. Even what it does, gets diverted into funding a few spectacular projects, not into resource-building. I would think that the government will be well advised to raise a National Fund for Cultural Development along the lines of the National Fund for Rural Development, giving the same incentive to donors (100 per cent exemption from income tax). Not only will this quicken the action but also give the donors the satisfaction of being active participants in the country's cultural development.

The government's new plan for economic development is going to put cultural institutions under great stress; especially the traditional arts—or what we call crafts or artisan arts. That the paper includes the so-called crafts under arts is encouraging. These cannot survive the pressures of a free-market economy; or, if they do, they will be distorted out of shape. The suggestion is to isolate those areas of artisan art that are highly sophisticated (and that subsisted on the patronage of the affluent individual or social institutions) and bring them under state patronage; get them to work for the state in 'karkhanas' (as in Mughal times), enforcing the highest standards and underwriting the whole production. This alone will help keep such arts alive. And the government will not regret this, as such arts are becoming rarer and rarer on the world scene; they will eventually be considered world assets and arouse appropriate interest.

Their products can be housed in prototype museums to educate the tastes of new talent, used in government buildings or given as gifts to dignitaries; even sold in special government shops at appropriate prices. Another important matter for the government to give attention to is the institution of national museums in each major field of expertise—textiles, woodwork, metalwork, ritual arts, household (including culinary) arts, architecture, theatre arts, etc. etc.

I am a little amused by the frequent use of the expression 'guru–sishya parampara' on all national fora. I suppose the Westernized Indian reminds himself of his age-old culture by using these catchwords—guru–sishya parampara, yoga, mandala—lengthening the later vowels like an American would. That certain traditional arts, crafts and performing arts are best cultivated in personalized or

workshop atmospheres is true; music is better learnt in a conservatory, art in a studio under the supervision of an established teacher or homogeneous group of teachers. But the circumstances for the old paramparas no longer exist. Today's gurus are no more like the old gurus for all their talk of 'sadhana', 'nirvana' and the rest; today's students, too, are not so unquestioningly reverential. Nor do either want to stick to a set practice profile; they want to innovate. And for all their talk of purity of language, they derive great pleasure in hybridizing commodity profiles, mixing up ragas and dance styles, making distressing orchestral compositions and staging the most atrocious ballets. Nor were all the old gurus so exemplary. Have we forgotten the reason for the organization of the Gandharva Mahavidyalaya? I do agree that certain artistes do need long apprenticeships in a certain style (or practice profile) and their quality depends on the inner freedom they gain by this constant practice. It will be useful to document, analyse and codify these practice profiles and study their similarity and differences and possibilities for growth. Today's electronic media and the computer can do this dependably. Then a student can gain insight into these and make his own choice—as most of the modern gurus are unwilling to analyse their work-systems and seek new avenues of development; they are content to pass on the forms and themes that a parampara started out with but which are now largely out of context. And their language has no equivalent for our experiences in the modern context. While these traditional arts have to be studied for their special linguistic structures, the new generation of practitioners should be encouraged to live up to the times through these.

I appreciate the mention of heritage zones in your paper. I hope these will have necessary legal and other safeguards. Already many such zones have been encroached into and vitiated. This is certainly urgent. While this should include ancient sites and monuments, parts of towns, special buildings and environments, certain modern cultural landmarks, like Kalakshetra or Santiniketan, should also be brought in. I will stress the need to take quick action in the case of Santiniketan, as the place is urbanizing fast and, without a compact campus demarcation, is finding it hard to protect itself. Even the development authority that has been set up by the West Bengal Government to protect its interests is doing just the opposite; it is encouraging urbanization on a big scale.

Yours sincerely,
K. G. Subramanyan

FOUR

K. G. Subramanyan
Professor and Head
Department of Painting
Kala Bhavana
Santiniketan 731235

22 September 1983

Dear Shri Joshi,

Your D.O. NO. 7-11/82-Sch 5 dated 12 August 1983, thank you. It was redirected from Baroda. I am now in Santiniketan and working in Kala Bhavana (Visva-Bharati).

Most people will agree with you that there has been a kind of erosion in our values, and will be happy to know that the government is exercised about it and wants to devise measures to counteract it. This should have been thought of long ago. But, better late than never.

Before I write to you of my reaction to the specific measures you propose in your letter, I need to spell out my views on the whole question, even if it means underlining the obvious.

For all our pious talk, we are living in a society where nothing succeeds like success, regardless of whether the means used to achieve it is fair or foul. This is so in politics, in industry, in commerce, in the ways in which people secure personal or group advancement; it

is becoming increasingly so in other fields too. The use of unfair means is widespread and no longer looked down upon. On the contrary, the use of various coercive methods to secure one's ends is found acceptable to people of all persuasions, and an honest man is considered a freak or a fool, even in polite society.

One may say that this is nothing new, that things were not much better in days gone by, the only difference being that there were more hypocrites at that time. This could well be. But as someone has said, hypocrisy is the tribute vice pays to virtue. In today's pragmatic world, where the only recognized virtue is to succeed by hook or by crook, there is no need for such tributes.

If the adult society that we are part of holds 'values' in scant respect, how can that society presume to educate its youth in those values? Even if it really means to do so, in a spirit of atonement or redress? We all know that values have to be taught more by example than by precept. With what face can a successful man of today teach his son honesty, fearlessness, uprightness, consistency or patriotism, when he knows he has lied, cringed, compromised and changed his stands to be where he is? And that he will easily trade off his country's interests for a little personal gain? And, worse still, when his son himself knows that this is so?

I am therefore of the opinion that unless there is an improvement in the standard of values in adult society, even an apparent improve-ment, it is useless to pretend that we can educate the youth in the right values. I may be asked: do we then let things be as they are or allow them to go from bad to worse? Even if nine out of ten persons want things as they are, cannot the remaining one try to change them for the better?

Let us say he can. How will he do so?

One way would be to call death to the existing value-system and seek to replace it with a better alternative. Another will be to change it from within, by demonstrating to people, by whatever means, that a society with the right values is (or was) better than one without; that even if one gains in success and stature by unfair means, he cannot help looking poor and mean in his own eyes.

This can be done through the usual avenues available to us—education, mass-communication and group activity. At one time, such avenues were provided for within the stream of community life through its successive stages—the individual interacted with his parents, his family, his community within an accepted system of norms, notions and beliefs, and received from them a sense of values within a charged emotional nexus, values that entered his bloodstream, as it were, through such devious and indirect channels as grandmother's tales, folklore and rituals, social customs and observances. This is no more so; nor can it be so in a society that is constantly changing. This is what sets us a problem in the way of 'value' education.

Value education is different in character and content from other kinds of education inasmuch as it means to build up in our feeling–thought–action processes certain acceptance and rejection responses to right and wrong respectively. For this sake, it has to, as it were, feed the message into the 'muscle' and this is possible only if the 'muscle' is softened and disinhibited by emotional inputs and if the delivery is direct. Naturally, this is a lot different from the transfer of knowledge or practical skills. But in present-day society, value education is attempted through the same channels as effect the latter,

the hallmarks of which are rationality, impersonality and directness. And this accounts largely for their ineffectiveness. Reasonableness needs more than rationality to become a moral emotion. Even well-argued sermons bore and open-edged didacticism scares away an informed, educated and well-meaning public.

The list of topics you have enclosed with your letter have been drawn up, as I see, to give our people a sense of pride in their history, their society, their traditions and the like, and build with this a kind of background against which they can face the challenges of the present. As topics they are all right; though they tend to read a little too much like the table of contents in a history or social-science textbook. Topics can be of one kind or another, but our main concern is how to instil in our youth the right values.

Radio talks and articles in the news media will not be, as far as I can tell, quite productive. The general standard of these have been so continuously poor that unless there is a massive, and spectacular, reversal in standards and a marked improvement in communicative appeal, no one will notice them or pay heed to them, even if they are spoken or written by illustrious men. Besides, all illustrious men may not be good communicators. So, value education has to be planned and designed with care; while the content should be collected from the most authentic sources, the delivery has to be conceived by communication specialists and, as already mentioned, it should be indirect and undercover and have marked sensory and emotional content. The media chosen should have the power to hold the public's undivided attention.

In my opinion, the most suitable media for this purpose at the present time is the television and the cinema, where you can link discursive message and visual appeal in various effective ways. Besides, film is a more persuasive medium of communication than verbal tracts and its range of delivery is large. The influence of TV programmes like *The Ascent of Man* (by Bronowski) or *Civilization* (by Kenneth Clark) on the global viewing public is only too well known. When once the attention of the public is grasped by programmes such as these, it can be further fed with supplementary literature and information; one can even draw it out in participatory projects. For tangible results, a programme of this kind should be conceived as a whole package—the introductory feature, the supporting literature and proposals for action. The study and research that goes into the production of a feature will itself provide the material for all these.

But all this will have to be supported with resources on a generous scale. The government that spends lakhs of rupees to encourage creative filmmaking, should not find this hard to do, if value-nurture has any priority. This alone will attract the best minds and the most innovative talents to work on the projects.

Over-detailing of topics will tend to curtail the operative freedom of the communication designers and should therefore be avoided. Broad headings (outlining the general objectives) will serve better as take-off points for both the scholar and the communication specialist. I give a few samples below:

—To discover the country:
 –natural sites: climate, flora, fauna
 –cultural sites: cities, temples, fairs, festivals

—To know its people: their languages, their cultural diversity

—To know its history:
 –political: growth of institutions
 –economic: growth of agriculture, technology, trade
 –cultural: ways of living, material culture, architecture, art, music, dancing, drama

—To know its philosophy and religion

—To know its great personalities

—To know the world: its people, its history, its culture and its traditions

—To pose problems in various areas and seek solutions: population, world resources, environment, goals of life, group conflicts, amity, etc. etc.

There may be other ways of visualizing these. What is really important is the design of the packet and its communicative efficacy, which has to be constantly watched and studied. The real proof of its efficacy will be in how this helps to build, in the public mind, the right attitudes and motivation to move towards right action.

I am sorry that this letter is long and does not give you any simple answers. But the problem you are concerned with is not a simple one.

With best wishes,
Yours sincerely,
K. G. Subramanyan

FIVE

K. G. Subramanyan
Faculty of Fine Arts
Professor of Painting
M. S. University of Baroda

Shri Saraf
Member-Secretary
All India Handicrafts Board
Exhibition Grounds
Science Pavilion
Mathura Road
New Delhi

18 October 1967

Dear Mr Saraf,

Thank you for your letter inviting me as a member of the newly con-
stituted Handicrafts Board to participate in its inaugural meeting
fixed for 21 October 1967. I am happy to be on the Board and hope
I shall be of some use to it. I regret, however, that I am unable to
attend this meeting since I am inescapably tied up with other things
at the same time. I shall, however, try to attend as many of your
future meetings as I can.

I see from the agenda that you are going to discuss some of your developmental programmes. It is gratifying to see that the functions of the Handicrafts Board have grown from year to year. Your report mentions the considerable impact its work has had on Indian handicrafts and its role in accelerating the output of goods, their export and the consequent increase in the wage earnings of the craftsmen. Naturally, every suggestion you have now is in the line of boosting this trend. I do not dispute the necessity of this; it goes a long way in the solution of the human part of the problem that the Board is faced with, i.e. providing the craftsmen with a viable livelihood. The craftsmen have long suffered neglect and exploitation.

There is another aspect of the problem which may sound academic at first but which, nevertheless, I consider fundamental. This is related to the clarification of two questions: what is the Board's attitude to handicrafts? What is the Board's ultimate objective? Is it to keep the craftsmen alive, or the craft alive?

It is possible to keep the craftsmen alive in reasonable conditions by making them produce more goods, by selling these goods where one can, as happens now in the export market. One can mechanize their tools and increase their speed of production and specify basic standards. If at some point the demand is less for some type of goods, you can encourage them to shift to other types. If such a mobility does not pay, you can rehabilitate them in production fields other than that of handicrafts. This is one way of looking at the problem and quite a valid way.

This attitude is naturally not concerned about whether there are any inherent virtues in the handicraft activity itself or what it

needs for its sustenance. In fact, its programmes will tend to water down the craft by a slow process of alienation of the craftsmen from the culture complex that has generated them and has so far been the meat and sustenance of their craft. For in the export market, the buyer (except in exceptional cases) is not tied by a chord of sympathy with the craftsmen. This is simply because his cultural orientation is so different. For him, the piece of handicraft is only another cute object. And by and large, the taste of the bulk buyer of handicraft is not quite dependable since he is primarily catering to the tastes of his mediocre customers. Nothing can kill a handicraft quicker than such mediocre patronage. This has happened to handicrafts in other parts of the world where they have been commissioned to pander to the needs of an export or tourist market. So we had better be wary.

If the Board thinks that there are certain inherent virtues in the handicraft activity itself, it will have to take a different attitude. It will have to separate within the Indian handicrafts field the areas which are alive and the areas which are dead. It will then probably have to plan to keep those active nuclei fed and sustained by what they need to be fed and sustained with, and leave the rest to themselves. It will have to survey the activity in its many aspects, and, if possible, investigate what gave rise to the activity and what gave it character and sustenance. After all, what we call handicraft in India is a many-tiered hierarchy. It covers home and folk craft—craft activities related to the life and beliefs of the common people, quasi-professional activities related to the patronage of the affluent. Each of these needs individual handling if they have to survive because the needs of each of these are different. To hitch them all to the professional

machine irrespective of their basic character is bound to lead to disastrous results.

I am quite sure that most of the members of the Board are alive to this part of the problem, though I do not see that any part of the programme is looking for a solution to it. I should think that a solution will lie somewhere in the area of making the crafts real and active within the country of their origin in terms of the needs of today before the needs of the foreign buyer is considered—or at least simultaneously with it. Such an orientation will give Indian handicraft its specific flavour and, at the same time, preserve in the present day its character. The world interest in Indian handicraft will survive only as long as it is Indian in the real sense of the word and not pseudo-Swedish, Finnish or Danish, however excellent the prototypes. The content of this flavour or character is certainly not the repetition of old decorative ornamentation or iconographical cud-chewing. Handicraft goods of real Indian character can result only if the Indian craftsmen make objects for the present Indian culture complex—not its historical counterpart of five centuries ago or its contemporary counterpart in another country.

So, to nourish the body of a craft is a different problem from the nourishing of the craftsmen. I would not dream of saying that the craftsmen should be cheated of the prospect of greater earnings and prosperity by export contracts; but I only wish that in the process we did not slay the goose that lays the golden eggs. That would be so contrary to even the most mundane objectives of the Board.

While I agree that what your predecessor-secretary has mentioned as the human problem is a considerable part of the question that the

Handicrafts Board faces, I would wish that it also recognizes the great necessity of tackling the other aspect and devotes part of its energies and resources towards it.

Yours sincerely,
K. G. Subramanyan

SIX

K. G. Subramanyan
Dean
Faculty of Fine Arts
M. S. University of Baroda

Shri Saraf
Member-Secretary
All India Handicrafts Board
New Delhi

5 May 1972

Dear Shri Saraf,

Thank you for the Minute of the Handicrafts Board's meeting of February 1972 in New Delhi.

Although the Minute touches on the points I went to make during the discussion, I am not sure it makes them clear enough. So I am writing to you to clarify them again.

The main points I went to make are: there are inbuilt hazards in hitching handicrafts to export trade in a big way, attractive though the returns might be; that if this is done, the various commercial pressures involved in large-scale export trading are bound to dilute their quality; and that what passes off innocuously as redesigning for new markets is liable to distort their image fundamentally.

In this, I was not making wild assertions. Every year, I have occasion to meet various artists, designers and museum men from overseas whose interest in Indian handicrafts is beyond question. Almost all of them have been downright contemptuous of the quality of Indian handicraft reaching their shores in recent times and, being passionate admirers of the Indian handicraft tradition, they have been deeply distressed at this fact. The last person to mention this to me was Dr Herman Goetz who had come to India only a few months ago to deliver the Jawaharlal Nehru Memorial Lecture and who, as you know, is an eminent Indologist and has spent his whole lifetime in the study and exposition of the Indian art tradition.

This should make us sit up and think and be more watchful of what repercussions our export trade is having on our handicrafts and, at a second step, on the body of our culture. The suggestions I have in this connection are hardly drastic.

First, the Handicrafts Board should organize, every year, a public exhibition of the prototypes of various handicraft goods that are being exported especially those that are bulk foreign-exchange earners and bring their exporters special commendation from the Handicrafts Board (in addition to profit).

Second, the Handicrafts Board should compare these goods with traditional items in the same line which have made our craft tradition famous.

Such a comparative study will educate us, and the public, as to what is happening in these fields, and if, as your directors suggest, there has been no depreciation in quality, we have nothing to worry about.

If, on the other hand, we find there is such a depreciation, as various knowledgeable foreign observers have been trying to tell us, we should have a strategy to counteract this. If only on a small scale. Here, too, the suggestions I have are far from being drastic or impracticable.

The first step in this direction will be related to the material conservation of our handicrafts and their study. The Handicrafts Board should make an all-out effort to:

—build extensive and authentic collections of traditional Indian handicraft products in each specific region and field;

—build comprehensive archives of each major handicraft product, studying its change through time;

—engineer the complete documentation of handicraft techniques from different parts of India; and

—sponsor specialized studies and publications on the basis of these.

This will ensure that even if, due to various compulsions, a certain area of Indian handicrafts becomes barren, we shall still have enough data with regard to it to easily plan its re-sustenance at any time we find possible. Such data will also help us in the critical assessment of the changes a handicraft product undergoes from time to time.

The second step is related to exploring how far we can go to modify the distortions that the export trade is bound to bring into Indian handicrafts and, if possible, to conserve a certain area of each handicraft from its impact, direct or indirect. I am not, by any means, advocating the cessation or even the curtailment of handicraft exports in view of the valuable foreign exchange they earn and

the employment, on whatever terms, it affords to so many crafts-men.

The bulk of handicrafts, I presume, divide roughly into two categories:

(1) exotics, i.e. objects with outlandish traits collected as souvenirs and mementoes;

(2) objects that fall easily into the spectrum of design and use of the commodities of another country. If the foreign users of handicraft are all men of critical sensibility, their demand for these, in either category, will be for objects of high quality. But in bulk exports trade, this will be too much to expect; the objects will generally go to the pedestrian consumer. For him, a bronze Nataraja and a Siva–Parvati plaster plaque are both exotica, and he will probably prefer the latter. Similarly, he will prefer from the objects of the second category those which are completely shorn of indi-vidual traits and, for this reason, will conform readily to his limited need. What passes off as redesigning is what goes to meet this need of his, and if a dilution of quality derives from this, it should not surprise us.

There can be an effective safeguard against this only if we control all export of handicrafts through a screening organization and offer only such commodities for export as will be in good taste and as would add to the traditional reputation of Indian handicraft, instead of adjusting the supply to the vagaries of demand. I can see that this is possible only if the state controls the export of handicrafts completely and, even here, the working would not be easy. Alternatively, what can be done is to mark out 'areas' in handicrafts—especially in the sophisticated ones—that would be specially nourished by the state

within the internal market situation, so that if other areas get impoverished in quality through the export and tourist trade, these pockets at least will be preserved as oases of influence. I am not suggesting that such a conservation should be effected within the nostalgia of a bygone day, by repeating old designs and motifs, but within the cultural facts of today and we should presume, with the generic strands of our culture still intact, the results will be as distinctive as in the past.

These are matters of great importance if we keep in view the basic relevance of Indian handicraft to Indian culture. I have been noticing of late that the All India Handicrafts Board is tending progressively to overlook this and centring its interest around trade and profit. I wonder whether the transfer of the Board from the Ministry of Commerce and Industry to that of Foreign Trade is symptomatic of such a change of interest. This matter cannot be explained away by saying that the production of handicrafts for export is only one-fifth of the production of handicrafts for internal consumption, since this one-fifth is of directive importance. Also, we cannot deny that the Board's discussions, in meeting after meeting, are mainly concerned with export promotion and marketing.

This situation is far from satisfactory, more so when we realize that even the colonial rulers of India, for all their ignorance and prejudice, looked upon the Indian handicraft scene with greater sympathy. Their officials made more reliable and authentic studies of these crafts than any of our officials have done since Independence, studies we still have to rely upon for basic reference. One even suspects that they looked upon the decay of Indian handicrafts with more trepidation and concern than we do. The best collections of Indian handicrafts and textiles are outside this country and, if this is so, we

have only ourselves to blame. Even today we have not come alive to this fact; if we did, we could still make exemplary collections of Indian handicrafts in different parts of India, in spite of the drastic defoliation of the scene by curio dealers; if we wait a few years longer, it will be too late.

I hope you will not construe all this criticism of mine as belittling the work of the Board in the various fields. As an artist-member of the Board, I am rather overly sensitive to the dangers that are threatening our handicraft tradition and would be failing in my duty if I did not point them out to the Board from time to time. You would agree with me when I say that, even after all these years of functioning, the Handicrafts Board has not been able to initiate any sizeable activity in the direction of collection and study, of archives and publications: it has not been even able to house its little central collection properly and make it available to the public; nor has the Board any positive machinery in its centres for a comparative study of the old and the new, and for meaningful extension of handicrafts in the present culture complex. Without these, the healthy survival of handicrafts in this country will be well-nigh impossible. After all, in the final count, the contribution of the Board will be gauged not by the piddling profit it contrives to earn through its export drives from year to year, but by its efforts to nourish and fortify the Indian handicraft tradition, which has been a major part of India's cultural image throughout its history, and which, let us hope, will continue to be so in the years to come.

Yours sincerely,
K. G. Subramanyan

SEVEN

K. G Subramanyan
Visiting Fellow
Kala Bhavana
Santiniketan

Mr J. N. Benjamin
Chief Architect
Central Public Works Department
Nirman Bhavana
New Delhi

28 January 1978

Ref: D.O. NOS 37/15/77 CA dated 23 and 26 December 1977
and 17 January 1976.

Dear Mr Benjamin,

I have your three letters, thank you. When your first letter and, following that, the blueprint of the ground came, giving one such a ridiculously small notice to present a concept for the proposed Gandhi Memorial, I thought I was within my rights to keep quiet over the matter. But now that you have sent a reminder and given me more time and explained the background of the project, I presume I owe you a reply.

The project does not, somehow, rouse any enthusiasm. First, I do not feel that the site is appropriate for any monument to Gandhi; large though the grounds are, I cannot imagine a monument to Gandhi ringed by a busy motorway, in the vicinity of so many ungainly buildings and in front of the pompous bureaucratic complex, unless one thinks of something that will put them into shade and that is, consequently, very ambitious. But more than this, what makes me flinch from the project is its inappropriateness at the present moment in time.

The only adequate monument to a person like Mahatma Gandhi will be building up this country in the image of his basic vision. But granting that it does bring comfort to our poor selves to pay symbolic tribute to such a great man as he, it should be done after some noticeable step has been taken in this direction. When the poor in India have a chance to live reasonable lives, when the villages of India have managed to be clean and beautiful and to coexist with creative industry, when there is in the country a concerted effort to wipe out the inequalities of men to a conceivable degree and there is in its air a sense of gaiety and fulfilment—then such a monument to Gandhi will be appropriate and the people of India will respond to it with enthusiasm. In the absence of this, even if it is a well-intentioned gesture, it will be construed by the commonality of people as a pompous ritual of the people in power to build their own images. To make Gandhi seem an accomplice in this is doing him great disservice.

I know that writing such a letter does not serve my interests as an artist and I am foregoing the opportunity of tackling a challenging project, but, having lived through the generation of this country's

liberation from foreign rule and having had the chance to see the great man in action, my feelings in the matter cannot be contained entirely by professional interests.

Yours sincerely,
K. G. Subramanyan

PS I wonder whether you can share this letter with the Minister of Works and Housing, and if he will share this with the members of the Cabinet.

EIGHT

Shri B. L. Roy
Under-Secretary
Ministry of Defence
Government of India
New Delhi

23 August 1976

Dear Shri Roy,

I have your intimation of a meeting in the Central Committee for Tableaux on 31 August in New Delhi. I regret I shall not be able to be in Delhi that day. I am, however, sending my views in this matter in writing.

After seeing the brief you have enclosed with your intimation, I think that the presence of a member like me on the Committee is hardly necessary. Seeing that the decisions with regard to the nature of the Republic Day parade or its thematic break-up have already been taken, what you now need to do is to locate a good design organization and ask it to visualize it in the best way it can. And get these executed through your normal channels.

The concept of a Republic Day parade as a huge advertisement rig-up does not seem proper to me. I am probably old fashioned in this matter. In my opinion, the yearly Republic Day parade should

be a solemn ritual act, combining dignity and colour and symbolic of the vastness, the variety, the solidarity and the strength of the nation and its guiding principles. Its form should be hieratic of sorts, although its image could change from year to year and its content be only marginally topical. And if it purports to publicize anything, it should be the reigning philosophy of the nation and not any special administrative measures, however significant. Which, in their turn, can be more effectively brought home to the public through other channels.

I feel that the government has not so far given serious thought to what our Republic Day parade should be like in the light of our guiding philosophy. We have gone largely by the example of commercial pageants in other countries (like the Cotton Queen or Rose Queen pageants in USA). We have not learnt any lessons from the picturesqueness and the gaiety of our traditional processions; we have not even learnt any lessons from the impressive parade of the Socialist countries of the world, whose enormous and colourful congregations of people is directly demonstrative of their guiding philosophy. It is high time that the government thought in terms of doing so and involved thoughtful designers in this exercise.

The image of a parade with motorized floats of the usual kind reminds me, more than anything else, of a convoy carting a heap of shaky stage props, billboards and sorry-looking people to a distant dump somewhere. I wonder whether there can't be any alternatives to these, or whether these themselves cannot be done better. Some of the floats in the metropolitan centres are probably put together with effort and skill but, in most of the provincial centres, they look little better than garbage trucks coated in gay paint.

I do not think that the nature of the Republic Day parade is suited to be a proper vehicle for the kind of publicity visualized. A moving parade, the image of which is before the eyes of the public only for a short length of time, cannot effectively use static components that need longer and more pointed attention or messages that are too particular. Also, mottos and slogans and tableaux of the usual kind do not carry much of a message to a public already stupefied by the assault of commercial and political advertising, day after day, through signboards and posters and handouts and radio and television; they will suffer the parade like they suffer the posters, diverting themselves with its amusing sidelights.

So I suggest to the Committee that this year we may assign the full planning and designing of the parade to the National Design Institute, Ahmedabad (the Director of which is a member of the Committee), giving them the freedom to visualize it and its themes in a novel way, with the use of the most effective media for the same.

And if the government finds it worthwhile, in future, to reconsider the concept of the parade itself and explore possible alternatives, I suggest that the best designers and design organizations in India should be involved in such an exercise; they should be given sufficient time to do so, and the results should be exhibited, discussed and publicized.

It is only through these that the state can marshal the best talent available in this country to tone up the quality of the parade and its communicative efficacy and, through this, make an impact on popular taste itself.

Yours sincerely,

K. G. Subramanyan

NINE

5 Residency Bungalow Camp
Baroda

Shri H. B. N. Shetty
Director of Industries and Commerce
Chepauk
Madras 600005

7 July 1972

Dear Shri Shetty,

I have Mr G. N. Raghavan's letter NO. 162821/HC A3/69 dated 20 February 1972 referring to a proposal to upgrade the sculpture-training centre at Mahabalipuram into a College of Traditional Arts, Sculpture and Architecture. I am sorry I have taken a long time to give you my opinion and that you had to send me a reminder. I have, unfortunately, been either heavily preoccupied or indisposed, by turns, in the last few months and so could not give the proposal the attention it deserved.

To have an institution to teach traditional arts inclusive of sculpture and architecture is a commendable idea. When the traditional social and economic structure that sustained these arts is breaking down and is unable to support the old craft–apprentice system, this is the only alternative to extend their life. But the structure of such

an institution needs mature consideration; to give new life to these arts, as I shall explain later, we need a special kind of institution.

We are not the first to discover the present plight of traditional arts. More than a century ago, when Jamshedji Jeejibhoy visualized an art school in Bombay (and made a handsome endowment towards its institution) or Mr Hunter thought of an art institution in Madras, they were acutely aware of this predicament and the institutions they planned had the sustenance and strengthening of the traditional arts as their avowed objective. But it is common knowledge today that these institutions did not shape up as they wanted; in the way they grew, they kept only the most cursory contact with the traditional arts, and, more often than not, worked counter-purpose to them.

This was certainly not due to lack of wisdom or goodwill on the part of the early planners nor due to their ignorance of the problem but, rather, due to the special characteristics of the new society and the institutions it threw up. The new educational institutions (for us, those teaching art) catered, on the one hand, to the needs and tastes of the new society (in art, the demand for engravers, photographers, portraitists, monumental sculptors, graphic artists and the like) and, on the other, evolved a discipline that would equip a practitioner to meet the growing needs of a growing society, broad and general, with an elastic standard of excellence, not pointed and definite as in the traditional arts, whose purposes and methods were more specific. (For instance, it would be easier for one to assess the performance of a traditional art trainee—his terms being small and specific—than that of his modern counterpart in an art school.) But no modern academic institution can escape this tendency towards generalization if only for the fact that its graduates are unsure of the employment

situation they are finally going into. So, though I deplore the fact that our present colleges of art do not have a living contact with traditional arts (much to the detriment of both), I am afraid the setting up of 'colleges' of traditional arts will not save the situation either.

It could be argued that the employment situation that these craft trainees are going into is not so indefinite as I think, that threads of traditional culture still persist in our changing society, that people are still god-fearing and pious and need temples, viharas, ritual chariots and the like, if only on a smaller scale. It could also be said, with great justification, that the artists and architects of the new schools are unable to meet this need (and, if we can judge by the renovations of the gopurams of the Kapaliswara temple in Mylapore and the Meenakshi temple in Madurai, are incompetent and tasteless besides). But to think of a 'college' will not destroy its special character—it will turn out graduates like the other colleges do, 30 to 40 every year, who may not find enough work of the kind they are trained for and perhaps end up as petty modellers in museum workshops or in the workshops of curio-fakers—a most unattractive prospect. And if, eventually, more of its graduates go into these latter employments, it will adjust its teaching programme to meet this end. It will, in short, share the fate of the ayurvedic colleges; intended though it may be to sustain and preserve the purity of the traditional arts, it will only result in hybridizing them and watering them down.

This is not to be construed as my being against the setting up of an institution to teach traditional arts with professional status similar to that of a college. Far from it. My opinion is: an independent institution to teach traditional arts, if it is to be effective, has to be visualized on different lines from a normal college. To outline it briefly:

—it should start as a master-craftsmen's guild, preferably state-supported with enough professional work on hand;

—its educational functions should be related to its productive functions;

—it should be restrictive in its student intake;

—it should keep the master-craftsman–apprentice relationship intact in its teaching system;

—it should implement a course of the 'conservatorial' type (not the time-bound college type), sending out a practitioner with a professional certificate only when he has a high degree of competence and independence, in both theory and practice;

—it should be centred on a research department that probes into the rationale of the traditional arts, comparing their various iconographical divisions (as the present-day sthapathis, for all the hoary texts they hold on to, will be practitioners in the Nayak or the Vijayanagar manners, and the education of the apprentices should cover a larger spectrum of the traditional arts and present each form in its contextual propriety);

—it should have an area of environmental study (for a piece of sculpture or architecture does not become great by its iconographical precision but by its subtle responsiveness to the environment, both in design and visual content).

Then alone can such an institution play a creative role. Alternatively, such institutions can grow as postgraduate workshops around the

new art institutions, provided these art institutions take to such a link-up with favour. This would minimize their professional responsibility (since a student is going to specialize in these arts only after a basic art course, which will give him greater professional resilience). This will also be more realistic in the long run because it is inconceivable that a society can sustain two unrelated streams of art activity, one traditional and the other modern, for a long time without both growing impoverished and trite. But I agree that, at the present stage in our history, when there is a considerable wealth of traditional craftsmanship and related knowhow in our country to which our modern art schools turn their backs to a greater or lesser degree, an independent institution to foster them can be thought of. But, as I have mentioned, it should be carefully planned, and not put together scrappily as is being attempted.

The present proposal seems to me to be impelled by a notion (all too common in our country) that academic (or professional) improvement can only be achieved in certain routine ways, by upgrading a pathasala into a school, a school into a college, a college into a super-institute, with separate hierarchies of staff. I admit that our administrative bureaucracy can only understand such terms; for them, the money-value and professional status of a craftsman is less than that of a lecturer, of a lecturer less than that of a professional, whether or not this nomenclature denotes a functional difference. So every person or institution seeking improvement in status seeks to adjust himself or itself to these role-stereotypes, irrespective of their suitability. I have seen only too often the unfortunate consequences of such a masquerade; a master-craftsman abandons his

craft environment and becomes an academic and, in the course of this, frustrated and lethargic; an artist becomes an administrator, a craft apprentice a prospective graduate with his eye more on the certificate than on the craft. This will be most unfortunate. I am of the opinion that a master-craftsman or a sthapathi, if he is learned and adept, and is able to turn out professionals of competence, should be given the status of a professor without forcing him to change his work habits and sit on a professional chair. Similarly, a competent apprentice he trains should be accorded the status of a graduate without his having to waddle through a normal college-type curriculum. If this were accepted, I should presume those who drew up the scheme would have drawn it up differently (not worked under the notion that to improve the functions of an institute is to upgrade it into a college) and deliberated more seriously about the basic problems related to such education.

I am
Yours sincerely,
K. G. Subramanyan

TEN

Shri Bhagwati Shah
Secretary
Youth Services and Cultural Activities
3rd floor
Block NO. 9
Sachivalay
Gandhi Nagar

Dear Shri Shah,

Thank you for your kind letter of 11 July 1972. I am happy to hear that the Gujarat government is thinking of beautifying their offices, houses and public buildings. I am attaching with this a list of a few artists who may be of interest to you in this connection.

I would, however, like to mention here that the way to beautify buildings does not merely consist in strewing works of art around them. Most of our public buildings are ill built and ill maintained. Their interiors are shoddy, especially the office interiors which are probably the worst examples of visual disorganization—with files heaped everywhere worse than rubbish, with inelegant furniture, with drapes which are hardly better than rags. Few public buildings have gardens worth their name and, in most of them, the public facilities are filthy. If all of these are going to remain as they are, adding a few works of art to this confusion will not serve any purpose;

it will be as futile a gesture as repairing an ill-cooked dish with superficial garnishing.

I think that if the Gujarat state government seriously means to beautify its offices, houses and public buildings, it should first clean them up, paint them well, polish their fittings, plan their interiors with taste, use simple well-designed furniture, have the offices in better order and plant and maintain gardens around each of them. A work of art becomes appropriate only when these basic requirements are fulfilled.

To do these best and economically, the state government should have expert committees with young architects, artists, interior designers, horticulturists and landscape designers to plan the reconditioning. It should acquire or commission works of art only when there is a plan for such comprehensive reconditioning.

I hope you will not misunderstand why I write such a letter; while as an artist I am interested in promoting the state patronage of the arts, as a private citizen I am equally concerned that this patronage should be well conceived. To dump a few works of art on what is a disorganized slum is doing justice to neither. Also, when works of art are commissioned, the government will have to see that they get the best and the most appropriate works (through competitions or otherwise) or else they will eventually have on their hands a large body of mediocre work which they cannot put aside even if they want to.

Yours sincerely,
K. G. Subramanyan

The following artists of the Faculty of Fine Arts, Baroda, could be helpful in fields mentioned against their names.

Jeram Patel—Painting, planning interior design

Jyoti Bhatt—Murals, planning interior design, photography

Vinodray Patel—Painting

Gulam Sheikh—Painting

Vinod C. Shah—Mural, painting

Girish Bhatt—Sculpture

Rajnikant Panchal—Sculpture, relief

Mahendra Pandya—Sculpture, relief

Raghav Kaneria—Sculpture, relief

Krishna Chatpar—Sculpture

Nagji Patel—Sculpture

Feroz Katpitia—Painting, photography

Ramesh Pandya—Painting

Vinay P. Trivedi—Painting

Vinod S. Patel—Photography, interior design

Gyarasilal Mistry—Execution of murals

Other artists who have worked in our institution and can be helpful:

Bhupen Khakhar—Painting

Himmat Shah—Mural, painting

Balakrishna Patel—Mural, painting

Jayant Parikh—Painting

Eruch Hakin—Painting

Shanti Dave—Mural, painting

Other than these, you already know the artists of Ahmedabad and other parts of Gujarat who can be helpful in one way or other.

ELEVEN

Dean
Faculty of Fine Arts
M. S. University of Baroda
Pushpa Bagh
Baroda 390002

Shri S. M. Dudani
Education Secretary
Government of Gujarat
Sachivalaya
Gandhi Nagar

3 May 1973

Dear Shri Dudani,

I came to meet you on 21 March 1973 as you had asked me to, through Prof. Madan, and heard that you had to leave for Bombay the same day due to a bereavement. So Shri Arun Sinha, Director, Youth Services and Culture, and Shri Karbari, Deputy Secretary, took me to see the minister, Shri Chokhawala, with whom I had a brief talk with regard to the affairs of the Gujarat Lalit Kala Akademi.

Shri Chokhawala mentioned that the government sincerely wanted to put the Akademi into efficient working shape, giving it autonomy of function, and whatever suggestions have been volunteered with regard to its restructure could be discussed together with

a committee made up of you, Shri Rasikhlal Parikh (of C. N Vidyalaya), Shri Arun Sinha, Shri Jyoti Bhatt, Shri Gulam Sheikh and Shri Jeram Patel (three young artists of Baroda who have made certain suggestions) and I, and some workable plan finalized.

I presume that this has already been communicated to you. It was mentioned that to expedite matters the meeting would be called in the month of April; but since it has not so been, it is now possible only in July at the earliest, for a number of us will be on vacation during this month and the next.

I am, however, giving below the background of my present disinterest in the affairs of the Gujarat Lalit Kala Akademi, which you were curious about.

You probably know that the Faculty of Fine Arts at the M. S. University of Baroda has, through these years, earned a name, I hope deservedly, of being the foremost institution in the field in this country. It has been able to effect a basic change in the philosophy of art education and other institutions look forward to it for guidance. It has also been able to put Gujarat on the 'modern Indian' art map, many of its alumni being classed amongst the most serious and original painters, sculptors and designers of the day. This status naturally burdens its teaching faculty, and every one involved with it, with a considerable responsibility, and they tend to, as they should, measure all art activity by stringent standards and recoil from such as do not come up to their expectations.

When the Gujarat Lalit Kala Akademi started, Prof. Bendre, then Dean, Prof. Chaudhuri and I were nominated members of the Akademi, and we took part in its proceedings with great enthusiasm.

We were interested in making the Akademi the instrument for a cultural awakening in the state and so we made certain demands on it; we wanted it to rid the art scene of certain professional vulgarities, to get strict and maintain progressive standards of value assessment, to insist on 'quality' in all its activities, be they exhibitions, publications or simple observances; we hoped that, through these, it would rise to an exemplary status in this country. But over the course of the next three years, we found our hopes to be misplaced and our participation of no avail; the organization was quite happy to get along with a pedestrian and ritualistic programme, and 'quality' was far from being one of its objectives. Every effort was made to frustrate our suggestions; an offer from us to organize the annual exhibition in Baroda was bypassed by successful administrative manoeuvring; our suggestion that the prevalent classifications of art in the exhibitions were absurd and should be dropped was accepted one year and reversed the next. When it became rather obvious to us that the general official reaction to our suggestions was one of resistance or avoidance, we lost interest in the Akademi which was apparently quite happy to be a small instrument of patronage of the government. The government was satisfied that it was doing something for the 'cause' of art, and some artists were satisfied that they were being taken notice of by the government. And since its activities never approached our notions of a 'standard', it became embarrassing for us to profess active association with them.

Soon after the Baroda exhibition, I wrote a long letter to the Secretary of the Akademi, outlining my views about what the Akademi could do and was not doing. I cannot recall the exact text but the content was more or less as follows:

—the rationale of the establishment of Akademis is that, when traditional social patronage breaks down, the promotion of art and culture falls within the responsibility of a welfare state;

—to plan this, the state has to seek the advice of the best and the most active professionals of the region and institute a body that will hold them as members;

—its programme should cover two major grounds: (1) conservation, documentation and study of art that has been; (2) promotion, encouragement and enrichment of art that is;

—the first will involve undertaking (1) surveys and documentation of works of art, (2) selective collections of old works of art, (3) organization of a comprehensive library of art literature and an archive of art information and (4) programmes of research, conservation and publication.

—the second will involve undertaking (1) a standard registry of present-day art practitioners of professional stature, (2) an archive of art information relating to present-day art and artists, (3) exhibitions, to introduce art to the public, especially the work of contemporary artists, (4) provision of working facilities to artists, like studios, galleries, workshops, work materials, (5) state patronage of art, (6) sponsorship of art seminars, conferences, interstate and international exchanges, (7) improvement of art-education facilities and (8) art research and publications.

If all these were taken up seriously, the Akademi could really house an active nucleus of healthy cultural growth in the state.

I need hardly say that these suggestions were taken little notice of. I did continue my active participation in the meetings of the Akademi for a few more years but on most of my suggestions there was little positive action, whether it was with regard to deciding a symbol for the Akademi, or its sponsoring research programmes, or its involving actively a number of the young and talented artists of this region in its bodies.

So my interest in the activities of the Akademi has naturally waned. I do not want to, at my stage in life, waste my time in meetings of bodies to whom my advice is of no value or associate myself with activities whose results do not come up to my notions of standard. As I have already mentioned, being the Dean of the Faculty of Fine Arts of this university puts an additional burden of responsibility on me in this regard.

My interest in the improvement of the performance standards of the Akademi, however, remains and as you can find out from your officers, I have been useful to them in various ways with the help of our staff:

—in getting their artist registry scrutinized,

—in getting a documentation programme of the wall-paintings of Gujarat started,

—in advising on the production of the state's calendar for the year,

—in advising on their purchase of rare books, etc.

I have also been the chief guest at a few of their functions.

But unless there is a basic change in the composition of the Akademi involving the active young artists of the region, and its programme is broadened and accelerated and made more purposeful, the Akademi will continue on the same lines as it has, and I would not like to spend too much time on it. I have not resigned from the Akademi only because I am an ex-officio member and do not want to prejudice the possibility of a future Dean of the Faculty taking interest in its affairs if he so chooses, but, if things continue as they are, I would rather I am dropped from the membership. I think our institution is, in a small but fundamental way, making its contribution to the cultural scene in Gujarat, and we have considerable satisfaction in keeping it functioning in the right direction; none of us, and least of all I, want to be member of any committee just for the honorific status.

Yours sincerely,

K. G. Subramanyan

TWELVE

Faculty of Fine Arts
M. S. University of Baroda
Pushpa Bagh
Baroda 390002

Secretary
Gujarat Lalit Kala Akademi
Ahmedabad

19 July 1971

Sir,

I have your announcement of the meeting of the General Body of the Akademi and the Agenda. But I am not sure I will be able to attend the meeting.

So I want to express my views on the request made to the body by some artists of Gujarat to restrict the competition in its exhibitions to Gujarat artists alone, through this letter.

I think this will be a most retrograde step to take.

First, it would be most unjust and unbecoming of a state cultural body to exclude from its activities people on regional or linguistic grounds. The cultural life of a state is not built solely by people who live long years or hold property on its soil or speak the local language; in fact, people of various kinds strengthen and add variety to its cultural fabric.

Second, this would defeat the main purpose of such exhibitions which I presume is to push up standards by providing a platform on which there can be the widest and the stiffest competition. To win a prize in an exhibition that is restrictive of talent on linguistic or other grounds would be of hardly any credit to any artist; in fact, if the standards are watered down in this way, it will offer no incentive to any serious artist to take part in it.

Third, any state of any cultural maturity will widen and not restrict participation in its activities or growth by people elsewhere; in fact, the Gujarat Lalit Kala Akademi should think in terms of making its exhibition an all-India one. If one realizes that about 15 to 20 of the National Award winners are either resident in Gujarat or affiliated to it in other ways, the coming generation of Gujarati artists need not be too despondent of holding their own against the stiffest competition.

Personally, I would think that the Gujarat State Exhibition should invite the widest and most generous participation. If the Akademi does not want to make this an all-India exhibition and prefers to keep it an all-Gujarat affair, it should at least be generous enough to invite every working artist in the state (and every art student registered in its institutions), irrespective of where they come from or what language they speak or how long they have been residents or any similar parochial consideration.

I am
Yours sincerely,
K. G. Subramanyan

THIRTEEN

Miss H. K. Singh
Art Education
Ministry of Education
New Delhi

11 May 1977

Dear Miss Singh,

You have referred to me during this year a number of research projects by American scholars (sponsored by the American Institute of Indian Studies) on various topics of Indian art / art history; I have recommended most of these as the applicants are properly qualified, the projects are viable and they have proper financial and academic support; and I am happy that a number of young scholars (irrespective of where they come from) are attempting to clarify the scene by various specialized studies.

At the same time, I wonder why our educational agencies, whether the Education Ministry or the UGC, are not trying in a large way to support within the country such research activity; it certainly cannot be because we do not have the talent—most of our young men do not undertake such research because they are unable to put up the necessary funds for travelling, visual documentation, etc., and there are not many institutions that help them in this. So, they confine

themselves to desk research—the value of which is naturally restricted. This is a situation that we need to remedy soon or else, in a few years, we will have to depend on the studies of foreign scholars and foreign expertise to clarify to ourselves our own art scene, which would be shameful. And we would not have enough specialists in or own country either. I hope you can do something about this or at least bring this matter to the notice of people who can.

To cite a specific instance: one of my colleagues, Shri Jyoti Bhatt, a good artist and photographer, has been interested in documenting the murals in the smaller temples of Gujarat; he has also done some exploratory work to this end. I have been trying to get him some financial support for this from our own university and UGC but without any encouraging results. Yet only a few months ago you referred to me a project sponsored on the same subject by the American Institute of Indian Studies—on behalf of an Indian scholar married to an American. I have recommended the project simply because it cannot wait; and Mr Jyoti Bhatt has already waited too long because of the short-sightedness of our educational agencies, and many of the murals are being scrapped or painted over. But I do feel sorry that earnest individuals in our country cannot get the resources they need for worthwhile work and have to make way for those who have the support of foreign funds. This seems to have no priority at all in our educational planning.

Please do drop me a line.

With best wishes,
Yours sincerely,
K. G. Subramanyan

FOURTEEN

Baroda

17 August 1972

Dear Ravi bhai,

I am very happy to get your letter. The views I have expressed in the interview are the views I have always held; only, I am a little clearer about them now.

I feel that our problem has been that we have tried to contact the norms of the contemporary West while the norms of our historical past but have rarely tried to contact our contemporary environment and find out its norms. This problem is not new; it dates from your own generation—one that dilly-dallied between the academic manner of the West and the courtly manner of the miniaturists; it has continued into ours, except for the fact that it dilly-dallies now between minimal abstraction and tantric diagrams. When I am pleading for a contact with the environment, I am pleading for something more basic, not one at the level of languages or manners in vogue, at a time here or elsewhere—but an awareness of the physical and intellectual facts around us in our time and its own compulsions, which will give a new rationale to our work. This will

probably result in a work that is as different from the work that has gone before us, as the miniatures were themselves different from the work of the Ajanta caves; it may also find parallels in the work of the modern West, as our miniatures had parallels in the Gothic miniatures or the Amaravalli reliefs had in certain Graeco-Roman reliefs. So, really speaking, I am pleading for the discovery of this rationale by artists, in 'their' own individual ways, irrespective of what subsequent parallelisms may result.

So I would not like to be construed as an advocate of cultural Puritanism. I do think that there are many things which are part of our thought and environment today which we owe to the West and gainfully so. This is not a straight choice between East and West. My view is that Indian artists should view works of art, Indian or Western, in their contextual propriety (not by external look or manner); if they do so, it will help them to find a suitable vocabulary for their present context.

After all, when I know that structures that are so conceptually different like the Taj Mahal and the temple of Mahabalipuram are both environmentally appropriate in their different ways, why should I think that a modern Indian architect will not produce something very different from both these that will still be environmentally appropriate? But I believe that this appropriateness will depend on how he reads his contexts right, not by his fiddling about with modalities.

To amplify what I have said, I am mailing you a typed script of a lecture I delivered in Santiniketan a year ago (which they have later published).

Let me mention again that it warms my heart to know you took interest in the published interview. I hope this finds you in good health and you will visit Baroda as you promise. We want you to come and see what we are doing at present.

With my regards,
Yours sincerely,
K. G. Subramanyan

FIFTEEN

Baroda

25 May 1970

Dear Kamaladevi-ji,

I have received your kind letter and I feel deeply honoured at the suggestion you make. Only I am not too certain how suitable a president I will make; I am terribly tied up with this institution and for that reason I am not able to give a lot of time to other organizations I am already associated with, like the Lalit Kala Akademi, the All India Board of Technical Studies, the All India Handicrafts Board, etc. Since the Crafts Council of India needs a lot of building up as you mention, I wonder whether I shall be able to devote as much time to it as I should and live up to your expectations.

I recognize that there is a pressing necessity for building up an active craft movement in India; I feel it is a crying shame that, in this country where a great variety of craft skills still exist, there is no contemporary movement connecting up with them. And the more I watch the functioning of the All India Handicrafts Board, the more I am convinced that such a movement has to be built outside it. I am not unappreciative of what the Board does, but I am afraid that the present trends within it to treat handicraft as any other industry

and hitch it to the export wagon will do it enormous harm. I have mentioned this to the Board more than once, and pleaded for building up a positive core of activity within it that will preserve craft as a way of life; but this has so far met with little more than verbal appreciation.

So it will fall to the Crafts Council of India to do this and I am happy to find that this is mentioned as one of its objectives.

As I can visualize, the Crafts Council of India will have to do the following to effect this:

—get a solid membership of active contemporary craftsmen in India (although we have too few a number of them);

—work out a programme to increase their kind, in addition to the craftsmen in their traditional guilds;

—popularize craft skills in schools, colleges and fine-art institutions through inexpensive craft manuals;

—make easily available, through proper agencies, craft tools and craft materials for those who want to pursue craft skills creatively;

—exhibit the work so produced and offer it to public criticism;

—build a platform for the exchange of ideas between such craftsmen on all relevant problems.

If these have to be accomplished, I am painfully aware we shall have to raise some financial resources for it. And how will we do that? The contribution from members is not likely to raise very much. In

fact, many of the craftsmen or artist members will not even be able to pay their way to come to a conference; it will be difficult to expect them to do so in the realities of today. So, do we go for government subsidy? Or to private donors?

These are some points that I am not very clear about. You will be able to advise me on them. I am personally useless with these. If it is possible to build a working core for the above programme and have some basic resources, and if my physical presence is not always necessary to run the Council's affairs, I can agree to be its president as you suggest (following formal permission from the university); I can be helpful in getting the craftsmen artists in (the publication and training programmes and in exhibitions and conferences).*

I am sorry I have written such a long reply to your gracious request but, since the cause is dear to me, I thought I had better do so. The main objectives of the Crafts Council of India would be to keep craft alive in modern society and keep the highest standards (both of which the All India Handicrafts Board is not able to serve).

With kindest regards,
I am
Yours sincerely,
K. G. Subramanyan

* I can do all this even without being the president if the present Executive Committee accepts the programme; I would, in fact, prefer to do so.

SIXTEEN

26 March 1972

Dear Rai Krishnadas-ji,

Thank you for your kind letter inviting me to participate in the function releasing the Golden Jubilee volume of the Bharat Kala Bhavan; if Benaras was not so far and the notice so short, I would certainly have been delighted to avail of the invitation.

If I say that men of my generation owe their awareness of this country's tradition to such perceptive and knowledgeable collectors as you then I am not exaggerating a bit; the choice collection that you have built up in Bharat Kala Bhavan, of which I have had the chance to see only a small part, is one of those illuminating peepholes into our past which fills us with pride and hope on the one hand and something near to despair on the other.

That Bharat Kala Bhavan is trying to uncover these treasures to the public through exhibitions, studies and publications is a welcome development; the more this is done, the greater will be the contribution of this institution to cultivating a clear national perspective in our cultural growth. Our vision today is caught, as you are yourself aware, in a bag of slogans and verbal obfuscations and needs open contact with cultural facts, not their stilted interpretations.

In this a collection like that of Bharat Kala Bhavan can be an invaluable asset—a veritable 'sanjeevani', as it were. I wish that the institution will grow and prosper and pray that God may add many more years to your life to continue to give it direction.

Yours sincerely,
K. G. Subramanyan

SEVENTEEN

Shri. R. N. Mirdha
Chairman
Lalit Kala Akademi
New Delhi

24 April 1977

Dear Shri Mirdha,

Thank you for your kind letter. I have not been quite well of late and so the delay in sending a reply. I am touched by the confidence the Executive Board and the Committee have shown in me by nominating me as one of the members of the International Jury.

I, however, do not feel equal to the task. Although I have participated in a few international exhibitions and even won some awards, I have always wondered how the presiding jury is able to put its fingers on the winning exhibits from a whole multitude of deserving entries. For a single person to do so seems easy, as he can use his standard of judgement or his idiosyncrasy. But for a body of people with different ranges of choice to do so is still a mystery; like others say, they probably hammer out a consensus after much horse-trading.

65

Which is what I do not have either the inclination or the talent for. This is not to say that there is any better way of doing it or that the results are unsatisfactory; when I participate in such an exhibition, I accept the present ethic for whatever it is worth.

So, kindly excuse me. I suppose you should already have a panel of alternative names—but, if I can volunteer any suggestions, I would like to mention the names of Shri Prithwish Neogy and Shri Krishna Reddy.

With my regards,
Yours sincerely,
K. G. Subramanyan